COSMOGONY:
Night & Time

by

T. Crunk

BLUE LIGHT PRESS ❖ 1ST WORLD PUBLISHING

SAN FRANCISCO ❖ FAIRFIELD ❖ DELHI

Winner of the 2024 Blue Light Book Award
Cosmogony: Night & Time
Copyright ©2024 by T. Crunk

All rights reserved. Printed in the United States of America. No part of this book may be used or reproduced in any manner whatsoever without written permission except in the case of brief quotations embodied in critical articles and reviews. For information contact:

1st World Library
PO Box 2211
Fairfield, IA 52556
www.1stworldpublishing.com

Blue Light Press
www.bluelightpress.com
bluelightpress@aol.com

Book & Cover Design
Melanie Gendron
melaniegendron999@gmail.com

Cover Art
Jeffrey Bradford, *The Resurrection and The Life*,
acrylic and pastel on canvas, ca. 2008

First Edition

Library of Congress Cataloging-in-Publication Data

ISBN: 978-1-4218-3565-5

Night

the moon is

a pawned
wedding ring

 sun
 in the cellar

 oiling
 the stage machinery

ghost
of my
former sorrows

 a wind –

 and the bell
 regains its tongue

there are only
two stories –

leaving
and returning

　　　　　　　　　　the spider wakes
　　　　　　　　　　unspins
　　　　　　　　　　her web of light –

　　　　　　　　　　nightcity

the crush
and squall

of train metal

　　　　　　　　　　here lightning
　　　　　　　　　　has come
　　　　　　　　　　to heal the hand

each snowflake

a tinkling note
of a toy piano

　　　　　　　　　　haloes
　　　　　　　　　　in a cave

flock of sparrows
handful of syllables
shuffling reshuffling

in and out
of the seed mill's
rusted eaves

 heat
 has swollen
 the city shut

clouds
seal their lips

swallowing
the moon

 black water
 a mirror

 in which I
 watch my face

 fade
 slowly away

winter sky
gray as a war penny

 the moon is

 a light
 left on
 in a casket factory

tiny rose
of fire

blooming
at the tip
of a cigarette

 drought –

 iron earth
 bronze sky

all the beautiful
young heroes –

how could
so much life
not be doomed?

 under cover
 of darkness

 the city
 sets out

midnight
in cow town

widowed moon
bearing
her lonely heart away

 the slow ice
 of memory

 gathering

 crystal
 by crystal

chambers
and labyrinths

of an afterlife

 thieves of darkness
 keep giving me
 so much less
 to lose

fire
is the passage

the sunlight cold

 old death
 has circled
 back around

light
peering
through my body

my body
riddled with light

 as if night
 were smoke

 and morning
 its lifting

and living creatures
were among the coals

among
the wheels turning

 sky
 full of signs

 fields
 white for harvest

to ask the mountain
why the fool
is honored

 towers of light
 sweep the night sky

 tattooed
 with dust and smoke

 the smell of diesel
 and sawdust

 the howls
 of the carnival riders

pilgrim
in your
tramping rags

 the old
 poker dealer's hand

 trembling
 in the lantern light

to know that loss
is salt

the jewel
of great price

 moon
 bearing down
 like a free-through train

what once
had risen

returns now
as light

 the stars
 let down
 their lifelines

the sleeper's fingers
cascading
over the other
sleeper's hand

 there
 in the distance –

 thunder?
 a grieving
 father's question?

a misshapen coin of light
through the tear
in the yellowed windowshade

 swore he saw
 fire on the wind

whatever moves
and lifts

all trick hats
and veiled rigging

 pocks in the moon
 where the jewels
 fell out

our gaze
follows his silence
into the trees

 to whisper
 your name
 into the dark

 is never
 to call it back

hollow moon
the broken light

the chains
singing –

 trees
 our elders

 arms twisted
 misshapen

 from lifetimes
 of holding up the sky

how much
more sorrow
need I claim?

how much more
beaten furniture
going to weeds
in the alley?

 hole in the mirror

 blue eye
 gazing out of it

 untouched
 and untouchable

a prison house
a shadow city

the moon
bearer of wood
and water

 shadows mourning
 behind doors

 holding
 my death
 in my hand

when the fire
goes out
where does it go?

ask water
and pail
they should know

 there's a ladder
 in the temple

 reaches
 heaven's gate

 by day
 the moon

 gathers thorns
 for the fire

 she will burn
 by night

crows
contending in the beech arbor
like a clacking
of outraged widowers

 the cloud
 removes its mask

give praise

for the life
of iron
goes on

and the lives
of stone
and wood

they too
go on

 when I clap
 my hands
 you will remember –

 everything

the streets
burn with August

haze
nimbussing
the streetlamps

scalding the night
already raw

 going to meet
 my elders
 there

 going to
 wait there
 for my children

copper noon

 my lame shadow
 heavy

 with its sorrow
 falls away from me

I had made
a life

of trying
to divine

my own future

 sliver
 of moon

 sharp as
 a nick
 of a dobro string

black rose
blooming

 house on the cliff
 precarious

 as though poised
 to plunge into the next age

I saw the bones
walking

I said –
O bones

bones
do you

know
the road?

 bats

 chewing air

 in the tall pines

Time

black snake
slides past

the stone dial
that anchors

time to the sun

 the wind
 trapped in the loft
 of the white barn

 the wind
 in the bottles
 buried in the woods

here
at this altar

to confess
at last

to the broken mirror
the lost spoon

 the old gods
 tending
 the shoddy stage machinery

 the house dark
 the wings empty

the stitches
snipped

one
by one

the moon
in blood

drifts away

 like the word
 become flesh

 I entered
 not the great spaces

 but the small

distance
become sand

time
become shadow

 water
 over the rocks

 flickering

 a blue torch

angel of rain
on his treetop throne

no children no
said the stranger

you must leave
your shadows behind

 old man down the hall
 babbling gibberish
 through the night

the sand
that has besieged
and brought down

the towers
of righteousness
and wickedness alike

 the clocks
 inside the stones
 are turning

 inside the clouds
 the fire the air

this is
what it is
to walk truly
into the light

time
sweeps up
like wind in the broomsage

 to find
 my resting stone

 in a weary land

the bent man
the beaten man

 was I clay
 hung with rags

 was I a soul

 a godspark
 garbed in clay?

skull bones
of the great gods

who once
roamed the oceans

I drank a cup
of night

and became nothing

 the clock surrenders
 covers its face
 with its hands

kneeling
to touch
my mother's waters

leaves of the aspen
overhead
shimmering like coins

 breath
 not my own

 blooming
 in the air

the fish
asleep
in his cave

dreams fire

wanting
what seems so little –

to rise
above infirmity

to look down
and see the cities I've built

 draw near
 to the cross
 of my tomb

 leave
 your velvet ribbon –

 say farewell

how long
this life

– time's
many costume changes

 murmuring
 like the waters
 of forgetfulness

 or like the blood
 of the unrepentant

so much world

so so
much world –

under which brick
the secret lay

 and there
 at last

 you see them –
 tourists

 in heaven
 feeding fish

 from a glass
 bottomed boat

such great yearning
such urgent forgetting

 nor ever more rescue
 never lifted be

 o'er the perilous flood
 and carried free

steamplant whistle
at the Pen
blowing noon

above the machines'
roaring like storms of devils
caught in the gears

little stranger
little ghost orphan

how will you
come to me?

in the last
hour of night

tapping gently
at my window

or hovering
in the darkened room

just outside
this circle of lamplight?

 after our shadows
 have finished with us

claws
of the dried
tulip petals

 the mirrors
 eye each other
 across the room
 in which I left my voice

at dawn
the women will come out
to the well for water

the children
to gather corn

burnt out
cornfields

husks
of another dry day

hearse
driving back from the graveyard

 to pray
 that the clock
 have healing hands

 to wake in a house
 where my life
 has begun without me –

how late
my life has grown

no light
at the end

 struggling on
 seeking our own
 private miracle

a walk
beneath the circus tent
of heaven

held up
by the tangled scaffolding
of the black branches

from above –

the city's night heart
pumping streams of light

in and out
the highway veins

branching
into darkness

 for loss
 to be the coin

 with which I
 sought to buy
 my redemption

calendar and text
a telegraph key

the shadow
of the nail in the plank

 the shovel
 resting
 against a tree

 the barrow
 filling
 with sleep

smoke
across a hillside –

a signature

then
like a tree
with its shadow
at noon

he had taken
his silence
back into himself

 I saw my mother
 in a withered garden

 book open in her lap
 a locked gate

 a sealed tower
 a wind

 coming into her
 from the mouth of a dove

and yet
like a dream in which

we all
had become water

my otherlife
went on ceaselessly
 the hours

 clatter away at each other
 about the empty room

nothing
but the window
to protest
against the stars

door and wheel
coin and book
purse and nail
broom and chain
shoe and egg
cup and drum
candle and rope
button and knife
ring and bone
glove and pail
cake and thread
glass and key
hammer and lamp
harp and brick
horn and feather
bowl and seed
mirror and pitcher

 sky full of fire
 of Revelations

 this is
 what I remember:

cloak of feathers

a wafer
of frozen lake

 the mechanical
 fortune teller

 in her booth
 in the attic

 awaits
 the return of time

and when
the dead rise

none turn back

earth
was your mother

but fire
the hand that shaped you

 blind house

 the dark hours
 I watched
 at my window

pine branches
sketch
their impression of the wind

 blue bowl
 on the table

 the wasp
 a golden comet

 a breeze
 in the willow in the sideyard

justice by water
over and done

justice by fire
still to come

genesis: a hand
of fire
sails over the water

a stone
cries out
gives birth to darkness

 come
 little tree

 little tree
 we'll set out together

sparks
from the hammer stroke

hewing
chain from rock

 this at last
 is no dream

 my past
 one day
 will finally end

at night
the roads grow longer

into the future

About the Author

Tony Crunk's first collection of poetry, *Living in the Resurrection*, was the 1994 selection in the Yale Series of Younger Poets. He has published a number of subsequent collections, as well as works in a variety of other genres, including *A Theatre of Fine Devices*, winner of the 2008 Blue Light Poetry Prize. He currently lives in St. Louis.

www.ingramcontent.com/pod-product-compliance
Lightning Source LLC
Chambersburg PA
CBHW031219090426
42736CB00009B/990